Derek,
With love + best wishes
for Christmas 1998.

Love.
Tom
xx

HEARTWOOD

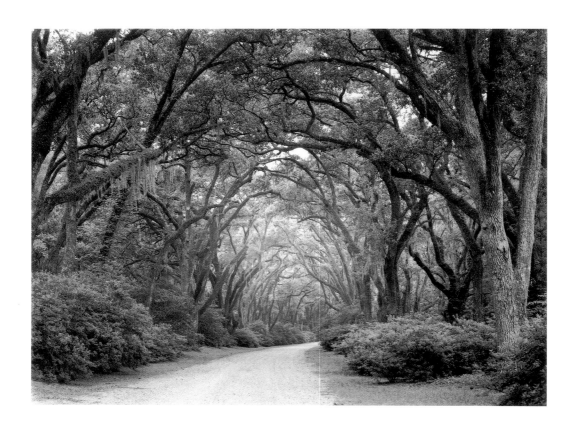

HEARTWOOD

Meditations on Southern Oaks

Poetry by Rumi ~ Photographs by William Guion
Translations by Coleman Barks and John Moyne

A BULFINCH PRESS BOOK
Little, Brown and Company
Boston · New York · Toronto · London

Library of Congress Cataloging-in-Publication Data
Guion, William.
 Heartwood: meditations on southern oaks: poetry by Rumi / photographs by William Guion. — 1st ed.
 p. cm.
 "A Bulfinch Press book."
 ISBN 0-8212-2531-6
 1. Photography of trees. 2. Live oak — Pictorial works. 3. Guion, William. I. Jalāl al-Dīn Rūmī, Maulana, 1207–1273. II. Title.
 TR726.T7G85 1998 98-10688
 779' .34—dc21

Bulfinch Press is an imprint and trademark of Little, Brown and Company (Inc.)
Published simultaneously in Canada by Little, Brown & Company (Canada) Limited

PRINTED IN ITALY

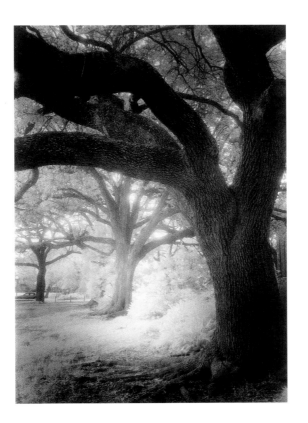

Dedicated to the trees,
the Spirit that resides there,
and to other seekers of that Spirit

CONTENTS

ACKNOWLEDGMENTS

Merci beaucoup to the many trees and people who helped bring this idea into form. First of all, to Kristin Ellison, Karen Dane, and the other kind folks at Bulfinch Press/Little, Brown and Company, and Kabir Helminski and Allyson Platt at Threshold Books. Without their support, my idea would not have grown to fruition. To the Live Oak Society of Louisiana, the horticulturists, staff, and friends at City Park, Audubon Zoological Gardens, Manresa Retreat, Oak Alley Foundation, and the many state parks, plantations, and gardens across Louisiana that allowed me to wander freely and often among the oaks. To Morley Baer, Rod Dresser, and Hunt and Tracy Witherill for their kinship and friendship, and to brother Rico Olivier for the occasional use of his darkroom. To my mother and father, to Mary Ellen Milks and Ethan Guion, Winnie Hart and the Hart-throbs for their continued faith, to Pat Elwick of Crown Sterling, Felicia Ferguson and staff at Lumina Gallery in Taos, New Mexico, and to all the many patrons and supporters of my journey into the light around the oaks.

ABOUT RUMI

Jalaluddin Rumi was born in 1207, in Balkh, in what is now Afghanistan. Early in his life, his family fled Balkh to Iconium, now Konya, Turkey, exiled by the Mongol invasions. Following in his father's footsteps, he became a scholar and theologian. He led a relatively conventional life until, at about the age of thirty-seven, he met the wandering Sufi dervish and mystic Shams of Tabriz, and a fast friendship took shape. In Shams, Rumi saw the embodiment of his concept of Divinity. Shams is supposed to have taken Rumi's books, thrown them down a well, and told him to begin living what he, until then, had just been studying.

His relationship with Shams changed Rumi's teachings forever. His writings became more poetic, and his poems were filled with a lyrical longing for *the Friend,* the spiritual presence he first perceived in Shams, and which underlies all of existence. The last thirty years of his life reflected the unfolding of this recognition in others, in the world around him, and in himself. Rumi died in 1273. He is revered and respected in the East, and today, through the translation of his work into English, his poems and teachings are finding a new and receptive audience in the West.

The short poems in this book are examples of writing from the middle period of Rumi's life when his work was very heart-centered. They speak of the joy and longing of his own spiritual striving and awakening.

INTRODUCTION

Throughout the ancient world, trees were considered sacred. They were animate beings with souls or spirits much like our own, yet often displaying god-like powers or qualities. Across history, the tree has symbolically represented the physical and spiritual aspects of human existence. Though life is rooted in the physical earth, the human spirit is inexorably drawn, like leaves, toward the light of the spiritual sun.

Of all trees, the oak has had special significance for many cultures. In ancient Greece, worshipers of Apollo believed that certain sacred groves of oak trees were oracular, places where humans could communicate directly with the gods. The oak was held to be the favored tree of Zeus and his Roman counterpart, Jupiter, gods of rain and thunder. Supposedly, the oak was struck by lightning more than other trees. In Germany, the oak was dedicated to Domar or Thumar, the German thunder god, and the equivalent of the Norse god of thunder, Thor.

The Celts of ancient Briton and the Basque peoples of southern France and northern Spain believed that groves of elder oaks were sacred sanctuaries. They would worship, hold meetings, and make important decisions under the oldest trees, believing the oaks would favorably influence their actions. The Druids, an ancient priesthood of advisers, judges, and tribal leaders to the Celtic peoples, were known for their veneration of oaks. *Druids* means, literally, "men of the oaks."

The Southern live oak species (*Quercus virginiana*) is a descendant of the ancient oaks that once covered much of North America. Today, *Quercus virginiana* grows only in a thin corridor rimming the Gulf of Mexico. This area extends west into Texas, east into Florida, then branches north along a splinter of the Atlantic coast into southeastern Virginia. The live oak is distinguishable among oak species mainly because of its shape and size. The limbs, when untrimmed or unbroken, stretch long and bend low, even dipping to the ground. A mature oak can form a mushroom-like shape with a domed crown that may grow more than 75 feet tall and 150 feet wide. It is called live oak because of its heartiness and longevity and because its leaves always appear to be green. Actually, the tree is a semi-evergreen and sheds its leaves periodically throughout the year, usually growing new leaves simultaneously. A single tree can live as long as a half dozen human generations and some of the oldest known of the species are more than 500 years of age.

A photographer friend told me once that to make more powerful and personal photographs I needed to find something I love and photograph it — over and over and over. When I looked around my native Louisiana, I found myself inexplicably drawn to the oaks. The more I slowed my pace to match theirs, the more the trees revealed their individual character and moods. The more I explored my deep feelings for them, the more I learned about myself and the magic and wonder of the oaks. As Rumi points out, everything has the potential to teach us. We need only be awake to our experiences and be willing to learn.

When asked by the editors at Bulfinch to consider a published writer for a collaboration with my photographs, I immediately thought of the poetry of Rumi. These photographs are not intended to illustrate or interpret his words or to change their metaphoric quality in any way. Rumi's poems are complete, whole. I have simply selected certain poems that, to me, resonate with feelings I have about my photographs. In most cases, the only similarity may be that they both describe experiences or emotions that cannot be contained in words but that can be understood by the heart.

Native Americans believe that the elder trees of all species have a wise and powerful spirit that lives in them. They say that when you walk among these elder trees and listen with your third ear, the heart, you can sense the presence and wisdom of their spirit.

In the years that I have observed the patient lives of the oaks, sat on their roots, walked under their arched alleyways, and recorded their many moods on film, they have taught me how to listen more with my third ear. At the same time, a growing compassion toward all life has taken root in my heart. This has been the gift of the oaks to me. My gift in return to them and to you is these images on paper of that light around the oaks.

WILLIAM GUION, *September 1997*

HEARTWOOD

There is no companion but love.
No starting, or finishing, yet, a road.
The Friend calls from there:
Why do you hesitate when lives are in danger!

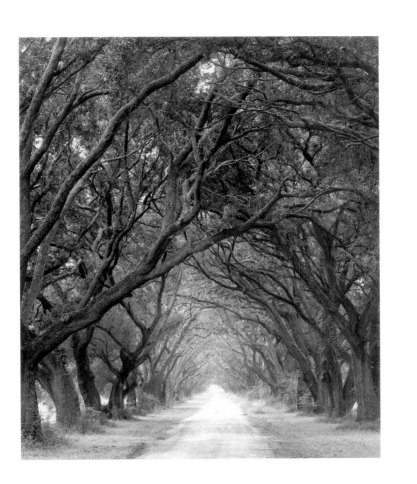

Come to the orchard in Spring.
There is light and wine, and sweethearts in the pomegranate flowers.
If you do not come, these do not matter.
If you do come, these do not matter.

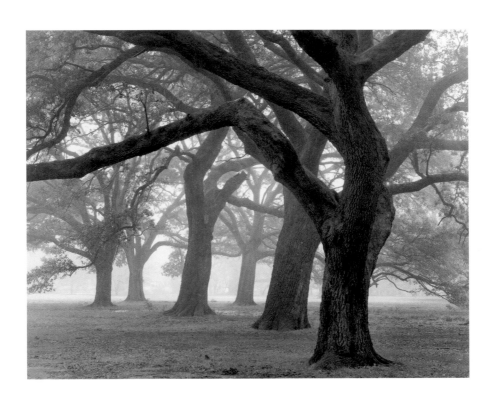

When your love reaches the core,
earth-heavals and bright irruptions spew in the air.

The universe becomes one spiritual thing, that simple
love mixing with spirit.

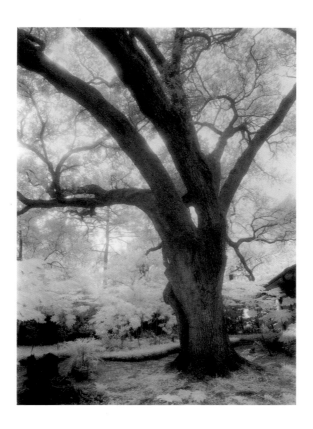

Listen, if you can stand to.
Union with the Friend means not being who you've been,
being instead silence: A place: A view
where language is inside seeing.

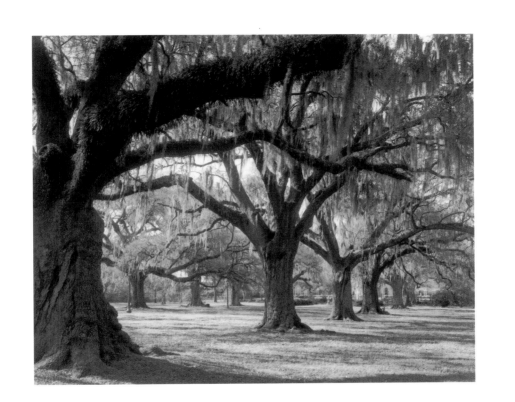

Something opens our wings. Something
makes boredom and hurt disappear.
Someone fills the cup in front of us:
We taste only sacredness.

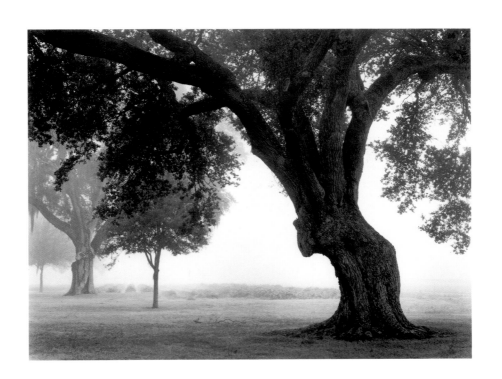

Our eyes do not see you,
but we have this excuse: Eyes
see surface, not reality,
though we keep hoping,
in this lovely place.

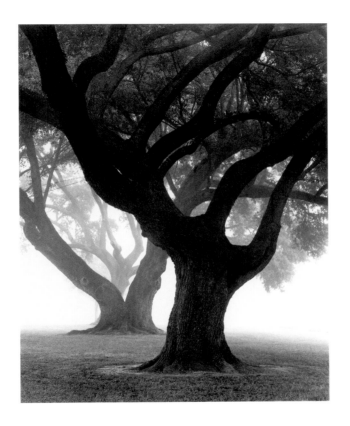

We have this way of talking, and we have another.
Apart from what we wish and what we fear may happen,
we are alive with other life, as clear stones
take form in the mountain.

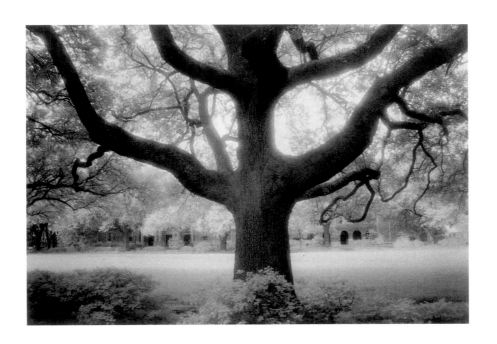

You have said what you are.
I am what I am.
Your actions in my head,
my head here in my hands
with something circling inside.
I have no name
for what circles
so perfectly.

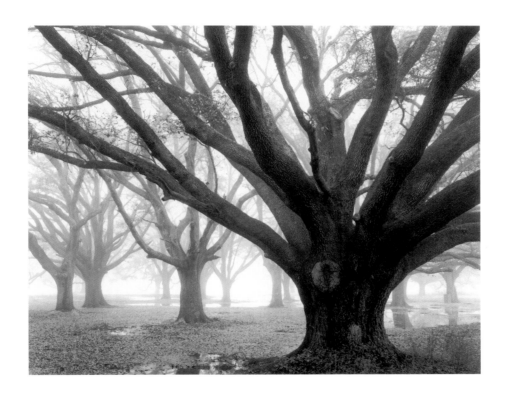

Being is not what it seems,
nor non-being. The world's
existence is not
in the world.

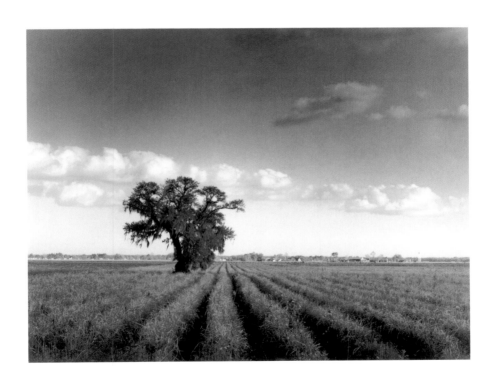

Since we've seen each other, a game goes on.
Secretly I move, and you respond.
You're winning, you think it's funny.

But look up from the board now, look how
I've brought in furniture to this invisible place,
so we can live here.

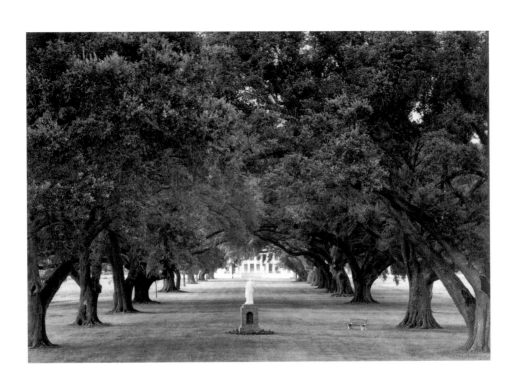

If you have a spirit, lose it,
loose it to return where with one word,
we came from. Now, thousands of words,
and we refuse to leave.

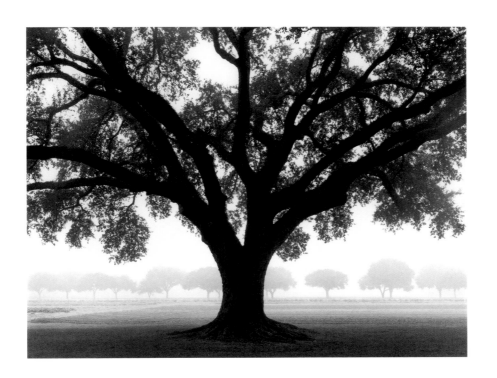

Walk to the well.
Turn as the earth and the moon turn,
circling what they love.
Whatever circles comes from the center.

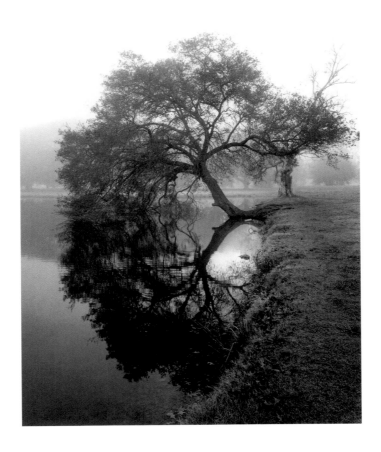

A secret turning in us
makes the universe turn.
Head unaware of feet,
and feet head. Neither cares.
They keep turning.

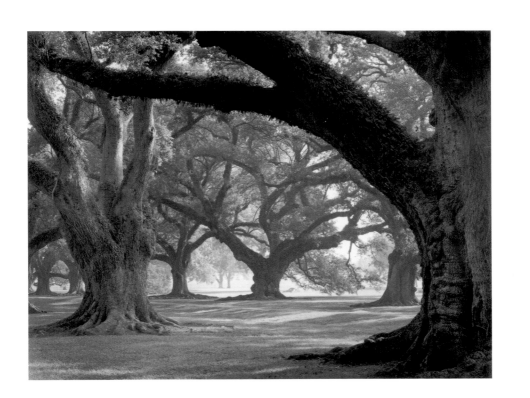

Where is a foot worthy to walk a garden,
or an eye that deserves to look at trees?

Show me a man willing to be
thrown in the fire.

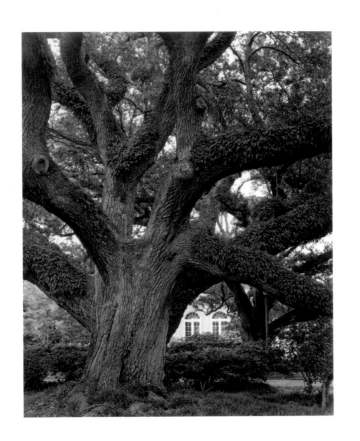

The clear bead at the center changes everything.
There are no edges to my loving now.

I've heard it said there's a window that opens
from one mind to another,

but if there's no wall, there's no need
for fitting the window, or the latch.

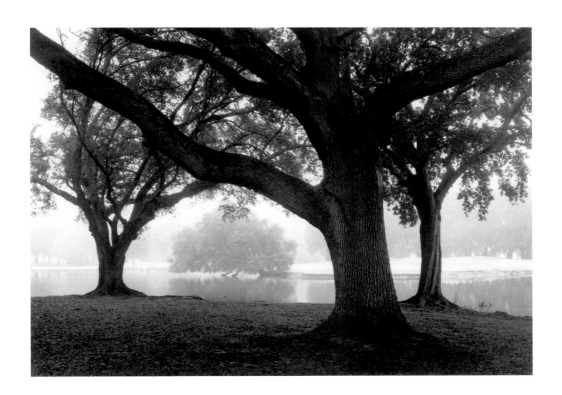

I can't tell my secrets.
I have no key to that door.
Something keeps me joyful,
but I cannot say what.

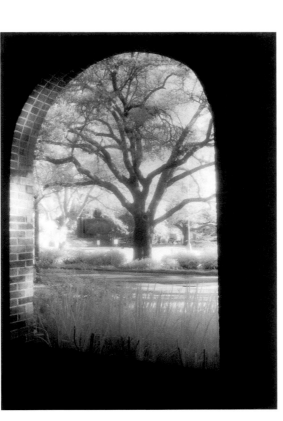

Listen to presences inside poems.
Let them take you where they will.

Follow those private hints,
and never leave the premises.

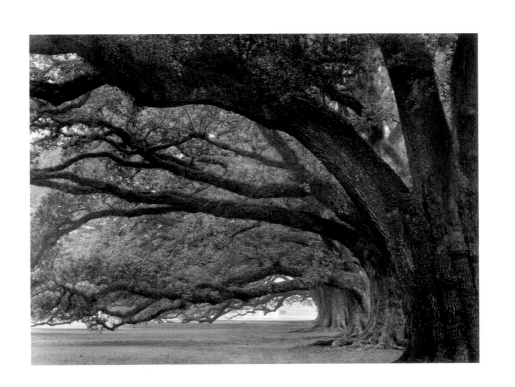

This moment this love comes to rest in me,
many beings in one being.
In one wheat-grain a thousand sheaf stacks.
Inside the needle's eye, a turning night of stars.

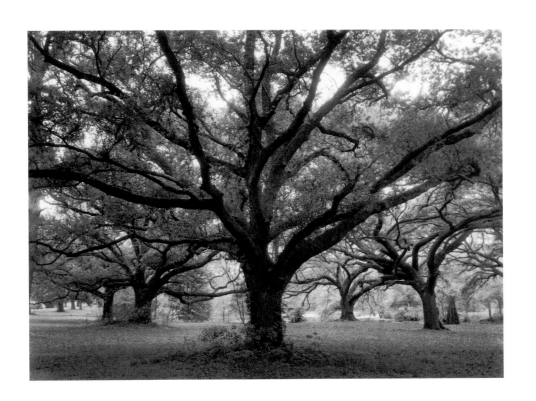

Out beyond ideas of wrongdoing and rightdoing,
there is a field. I'll meet you there.

When the soul lies down in that grass,
the world is too full to talk about.
Ideas, language, even the phrase *each other*
doesn't make any sense.

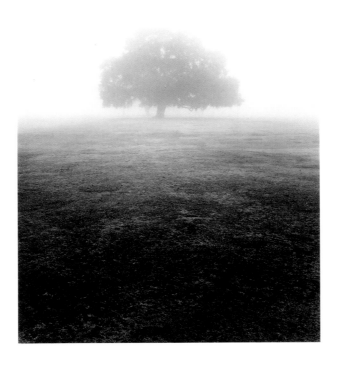

We are the mirror as well as the face in it.
We are tasting the taste this minute
of eternity. We are pain
and what cures pain. We are
the sweet, cold water and the jar that pours.

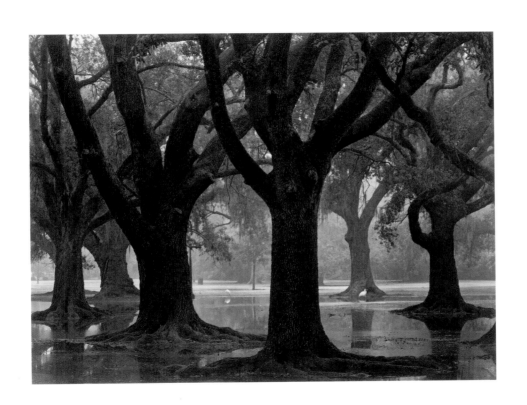

The minute I heard my first love story
I started looking for you, not knowing
how blind that was.

Lovers don't finally meet somewhere.
They're in each other all along.

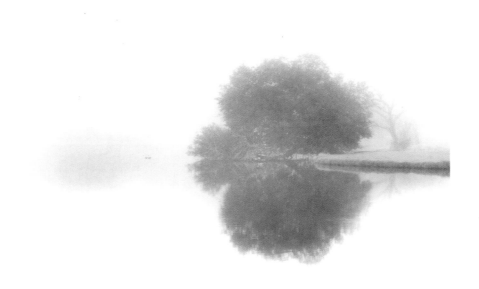

Friend, our closeness is this:
Anywhere you put your foot, feel me
in the firmness under you.

How is it with this love,
I see your world and not you?

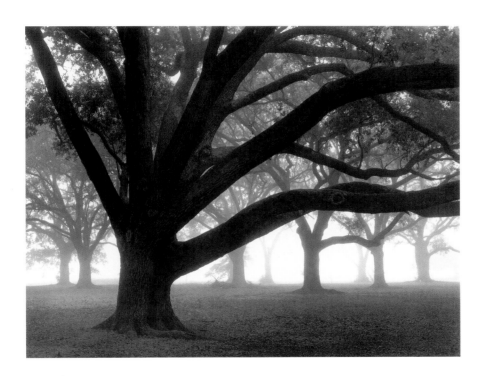

The breeze at dawn has secrets to tell you.
 Don't go back to sleep.
You must ask for what you really want.
 Don't go back to sleep.
People are going back and forth across the doorsill
 where the two worlds touch.
The door is round and open.
 Don't go back to sleep.

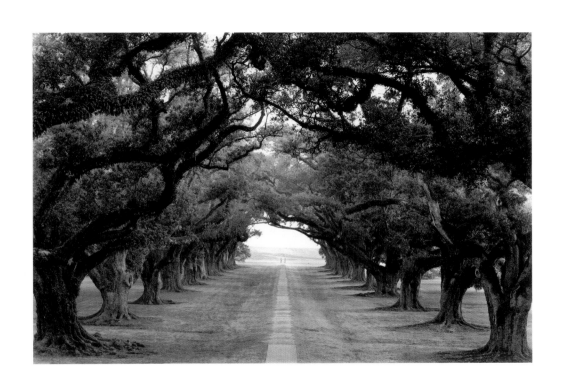

Life is ending? God gives another.
Admit the finite. Praise the infinite.
Love is a spring. Submerge.
Every separate drop, a new life.

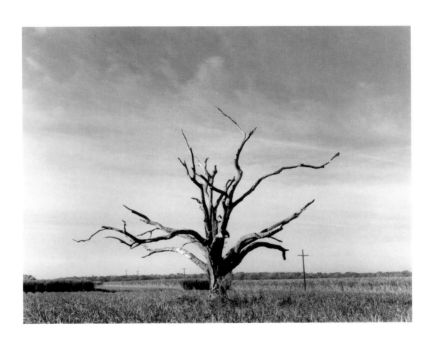

Keep walking, though there's no place to get to.
Don't try to see through the distances.
That's not for human beings. Move within,
but don't move the way fear makes you move.

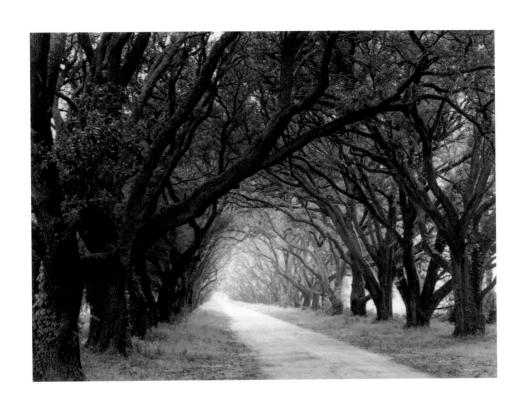

Do you think I know what I'm doing?
That for one breath or half-breath I belong to myself?
As much as a pen knows what it's writing,
or the ball can guess where it's going next.

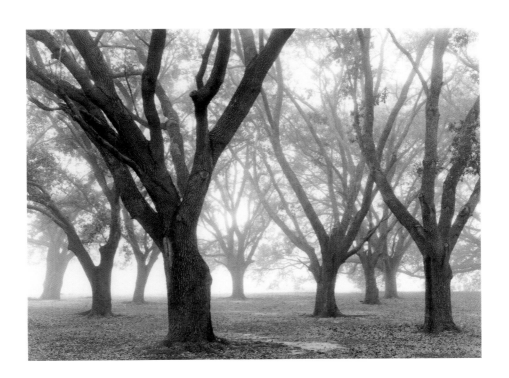

The morning wind spreads its fresh smell.
We must get up and take that in,
that wind that lets us live.
Breathe, before it's gone.

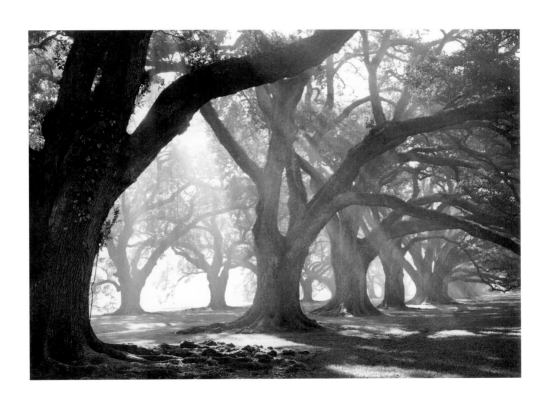

I honor those who try
to rid themselves of any lying,
who empty the self
and have only clear being there.

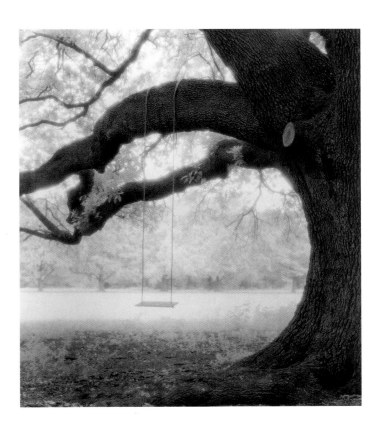

Inside the Great Mystery that is,
we don't really own anything.
What is this competition we feel then,
before we go, one at a time, through the same gate?

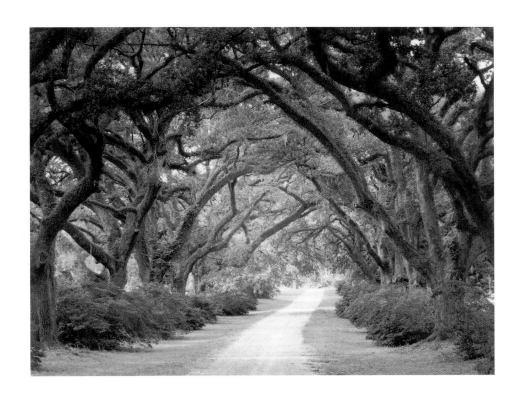

You were alone, I got you to sing.
You were quiet, I made you tell long stories.
No one knew who you were,
but they do now.

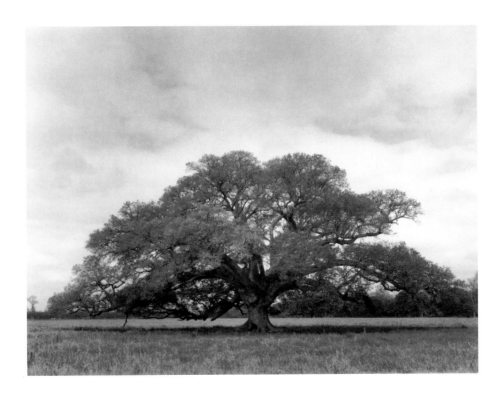

LIST OF PLATES

ABOUT THE ARTIST

William Guion has photographed the landscape and people of his native Louisiana for more than fifteen years. Through his camera's lens, he explores the quiet presence, or spirit of place, revealed in the changing moods of light and atmosphere. His photographs are contained in a variety of corporate and private collections and have been published in several regional and national publications. His interest in Rumi's writings grows from his affinity with Eastern spiritual thought. Currently, he is working as a writer and photographer and living in Utah, where he is working on future book projects incorporating his photographs and writing.

ABOUT THE TRANSLATORS

These translations were done by Coleman Barks in collaboration with Persian scholar John Moyne. Moyne is Head of Linguistics at the City University of New York. Coleman Barks is a poet and professor at the University of Georgia. He has published twelve books of Rumi's poetry, including the bestselling *The Essential Rumi*, and his newest release, *The Illuminated Rumi*. Moyne translates the Persian into English and Barks reworks the literal translations into free verse that is faithful to the imagery and tone of the original verse.

NOTES ON THE PHOTOGRAPHS

Most of the images in this book were made in the soft, diffuse light found at early morning, late afternoon, and on foggy or overcast days. The quiet, muted quality of light at these times allows the eye to perceive detail and textures in the usually shadowed spaces beneath the dense canopy of limbs and leaves. William Guion most often uses a four-by-five-inch view camera because of the slow, contemplative process of seeing that this large camera requires, and the ability it offers to control the development of each negative individually. Through precise development and printing of monochromatic photographic materials, he compresses or expands the black-and-white tonal scale to elicit and emphasize subtle emotional qualities of shadow and light.

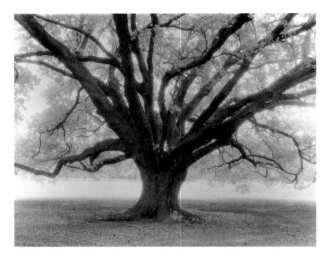

Type set in Centaur VAL
Designed and printed by
STAMPERIA VALDONEGA, Arbizzano – Verona, Italy